# PIGEONHOLED

*by the same author*

DISPATCHES FROM THE DIASPORA
ANOTHER DAY IN THE DEATH OF AMERICA
WHO ARE WE?
THE SPEECH
STRANGER IN A STRANGE LAND
NO PLACE LIKE HOME

# GARY YOUNGE

---

# PIGEONHOLED

*Creative Freedom
as an Act of Resistance*

INAUGURAL FABER LECTURE
DELIVERED IN LONDON, 2025

# faber

First published in 2025
by Faber & Faber Limited
The Bindery, 51 Hatton Garden
London EC1N 8HN

First published in the USA in 2025

Typeset by Ian Bahrami
Printed and bound by CPI Group (UK) Ltd, Croydon, CR0 4YY

All rights reserved
© Gary Younge, 2025

The right of Gary Younge to be identified as author of this work
has been asserted in accordance with Section 77 of the
Copyright, Designs and Patents Act 1988

Poetry quotation on page 21 is reproduced courtesy of Marwan Makhoul

A CIP record for this book is available from the British Library

ISBN 978–0–571–39661–0

Printed and bound in the UK on FSC® certified paper in line with our continuing
commitment to ethical business practices, sustainability and the environment.
**For further information see faber.co.uk/environmental-policy**

Our authorised representative in the EU for product safety is
Easy Access System Europe, Mustamäe tee 50, 10621 Tallinn, Estonia
gpsr.requests@easproject.com

2 4 6 8 10 9 7 5 3 1

*For Wayne and the love that outlives memory*

When I arrived in London for the first time, as a twenty-three-year-old to do a postgraduate diploma in journalism, I realised I had developed a couple of ticks. The first was that whenever I entered a room full of people, I always checked to see if my fly was down; the other was that whenever I saw a black person, I gave them a nod. There was a logic to these idiosyncrasies. I was raised in Stevenage in Hertfordshire, the youngest of three sons born to Barbadian parents, and had studied French and Russian at Heriot-Watt University in Edinburgh. Apart from a gap year teaching English to Eritrean students in Sudan, I had not lived around many black people beyond my immediate family.

So when I entered a pub in most Scottish cities or any rural area in Britain, there was always this fragment of silence as I single-handedly integrated the space. A barely perceptible instant, when the dart appeared to hover on

its way to the board and the flow of beer hung suspended between tap and glass – a shard of time long enough for me to notice, but short enough that anyone might claim you were imagining it. It was precisely in this fraction of plausible deniability that I would check that my zipper was up – in the knowledge that, for a fraction of a second, eyes would be on me.

The nod was, to some extent, an echo of the same experience. For, since I rarely saw other black people, I wanted to acknowledge their presence and affirm my own. Nothing elaborate. Just a brief recognition of impromptu, fleeting, wafer-thin solidarity based on nothing other than the assumption that they too may check their fly when entering a crowded room. A sign that, while I might be isolated, I was not entirely alone. No conversation was required; a nod would do.

Once I arrived in London, these ticks – so ingrained I barely knew I was doing them; so reflexive that I struggled not to do them – became redundant. The moments of silence on my entry into public space evaporated. Beer flowed unhindered, darts flew unencumbered. No one was looking at me. There were many black people in most social spaces. When I nodded at people, they either looked back

in bewilderment, as though I were a simpleton, or aggressively, as if I were facing them down, while I took on the persona of a nodding dog.

Coming into journalism in the early nineties, and book writing in the late nineties, was a bit like going into a rural pub. Black people were scarce. It would be an exaggeration to claim that you could to fit us all in a phone box – but a couple of those UberXL minivans would have done the job.

According to a *Guardian* report in 1999 – six years after I started my career – Britain's entire non-white journalism corps in mainstream national newspapers comprised twenty-eight reporters, ten editors and one columnist across sixteen titles. In seven of those publications, which together accounted for approximately half of all UK newspaper circulation, there was just one journalist of colour or none at all.[1] This was the year the Macpherson report into the death of Stephen Lawrence came out, introducing a significant section of the British public (and press) to the concept of institutional racism. Almost two decades later, black journalists made up 0.2 per cent of staff members at UK outlets, compared to black Britons making up 3 per cent of the country as a whole, according to a Reuters Institute for Journalism study published in 2016.[2]

Publishing, if anything, was worse. Two decades after that *Guardian* report the Police Evidence Centre found publishing and architecture the most elitist within the creative sector, with more than 58 per cent of those working within it coming from privileged backgrounds compared to 37 per cent of British workers as a whole. Since non-white people are more likely to be working class, racial exclusion was, of course, compounded and enabled by class elitism. Using raw data from a 2019 Labour Force Survey, PEC researchers could show that publishing was the whitest within the creative sector with only 5 per cent minorities.[3] According to a 2019 report by the Sutton Trust and the Social Mobility Commission, columnists are more likely to have attended private school and Oxbridge than High Court judges or members of the House of Lords.[4] (In an era of polarisation and populism, it is a reasonable, if not quite provable, assumption that the unrepresentative nature of the media has some bearing on publishing and journalism's struggles to be relevant.) So when I started my career as a journalist, back in 1993, my racial presence was conspicuous.

And in the time it took my colleagues to work out what my presence signified, I would check my metaphorical fly,

hyper-vigilant that I was not inadvertently laying myself open to ridicule, stereotype or worse, and keep nodding to the small, relatively junior group of non-white staff to whom the task of managing integration had, primarily, fallen. There was the day I had to explain to one senior editor why another senior editor should not use the 'n-word' during the morning editorial conference; the time I had to explain to union officials why they should not be drinking in the pub that the union voted to boycott because an Asian colleague had been racially abused there; or the colleague I had to upbraid after he said 'I'd be in for a hiding' if I ever wrote about reparations again.

But those were not the only expectations I had to manage, for the presence of black journalists, not unreasonably, prompted some black people to think that coverage might change. They hoped that the paper might deal with the black community with more empathy, approaching issues particularly relating to the black community more sympathetically and issues of racism in a more sophisticated manner. They would approach me with stories they felt weren't getting enough recognition, chide me about problematic editorials and other articles that I had nothing to do with, and questioned me about why we had so many more

correspondents in Europe than we did in Africa. I was criticised for not having covered the black trans community or Angola, asked why I continually dwell on black people in poverty when so many are excelling, and how come I got to present a documentary about Sean Combs (aka P. Diddy) when I clearly know nothing about hip-hop.

They call this the 'burden of representation'. For the purposes of this lecture, I will define it as the pressure exerted upon that relatively small group of people from under-represented communities who break through into elite spaces to embody, amplify, explain or advocate a set of needs, aspirations and interests relating to the community from which they come. That pressure may come from above, below, within and outwith, from those with power and those without; it may be driven by demands that are reactionary, progressive, reductive, enlightened, desperate or deluded.

In her 2021 autobiography, *The Year of Yes*, African American TV super-producer Shonda Rhimes, who was responsible for *Grey's Anatomy*, *Scandal* and *Bridgerton*, referred to it as the painful rite of passage for those she describes as FOD – first, only and different. 'When you are an FOD,' she writes, 'you are saddled with that burden

of extra responsibility – whether you want it or not. This wasn't just my shot. It was *ours*.'

It is a term often attributed to the African American essayist James Baldwin, who consistently addressed the issue, even if he may never have used those precise words. For example, in the spring of 1963, not long after the segregationists had turned their dogs and hoses on young black people in Birmingham, Alabama, he gave a talk at Howard University, a prestigious, historically black college in Washington, DC.

Afterwards, over a few glasses of Johnnie Walker Black, he told the students: 'Here's how matters stand. I, Jimmy Baldwin, as a black writer, must in some way represent you. Now, you didn't elect me and I didn't ask for it, but here we are. Everything I write will in some way reflect on you. So . . . what do we do? I'll make you a pledge. If you will promise your elder brother that you will never, ever accept any of the many derogatory, degrading and reductive definitions that society has ready for you, then I, Jimmy Baldwin, promise I shall never betray you.'[5]

It was not, for reasons I will go into, a promise that could ever really be kept. But his message to them nonetheless raises a range of questions: 'Do black writers

have a particular responsibility that others do not have?'; 'How is it possible to represent people to whom you are not accountable?'; and 'Who decides what amounts to betrayal?' It demands a reckoning with, among other things, what we mean by creative freedom, artistic responsibility, engaged writing, propaganda and the politics of identity and representation.

These are questions that pre-dated Baldwin.

In 1926, one of the Harlem Renaissance's poet laureates, Langston Hughes, wrote an essay, 'The Negro Artist and the Racial Mountain'.[6] 'The Negro artist works against an undertow of sharp criticism and misunderstanding from his own group and unintentional bribes from the whites,' writes Hughes. '"Oh, be respectable, write about nice people, show how good we are," say the Negroes. "Be stereotyped, don't go too far, don't shatter our illusions about you, don't amuse us too seriously. We will pay you," say the whites.'

Hughes effectively wrote a manifesto. 'We younger Negro artists who create, now intend to express our individual dark-skinned selves without fear or shame. If white people are pleased we are glad. If they are not, it doesn't matter. We are beautiful. And ugly too. The tom-tom cries

and the tom-tom laughs. If colored people are pleased we are glad. If they are not, their displeasure doesn't matter either. We build our temples for tomorrow, strong as we know how, and we stand on top of the mountain, free within ourselves.'

This lecture is not a call to arms, but a reflection about representation, power and responsibility, and how we navigate them. I am going to discuss it primarily in relation to issues of race and racism as they relate to writing because that is where I have, primarily, experienced it. But it is an issue by no means limited to race or literature. The issue could just as easily be addressed through gender, sexual orientation, religion, ethnicity or any of the other rogue cast of characters that comprise what we commonly refer to as identity. And I might just as easily come across it, albeit in a different way, in politics, business, music or sport.

I felt compelled to focus on this because it raises issues that have framed, frustrated, informed, inspired, impeded and inflected my entire working life as a writer. I both resent this burden for the limitations and intrusion that comes with it, and am grateful for the anchor and purpose it provides.

At this point, I feel the need to emphasise that, in this

regard, 'I am not', in the words of Zora Neale Hurston, 'tragically coloured'. I have had, and indeed am having, a long, rewarding and fulfilling career that has taken me across the globe, introduced me to amazing people and allowed me to witness incredible, historical moments, none of which would have been possible without wonderful colleagues and generous mentors. The fact that I have had to work hard and fight tenaciously for those opportunities does not distinguish me from most other writers. It is the type of work that I have at times had to do – and avoid – and the fights that I have had to wage that make this lecture possible and, I hope, necessary. 'No, I do not weep at the world,' wrote Hurston. 'I am too busy sharpening my oyster knife.'[7]

There has never been a time in my career when I have not felt it. My journalism apprenticeship started when the Scott Trust, which owns the *Guardian*, awarded me a bursary to study journalism at City University in London. The Trust issued six bursaries, with no promise of a job, to people who would otherwise be discouraged from going into journalism. Race was one of the categories; three of us were not white. When we arrived, some of our fellow students – particularly those who had applied for the bursary and not

been successful – told us we were only there because we were black.

As initiations go, it was both timely and clarifying, serving as an induction to a career in which my credentials for being in this industry would be up for debate. During my career, it's been claimed that being black is the only reason that I was sent to cover the South African elections in 1994, received a coveted fellowship to work at the *Washington Post*, was given a column at the *Guardian* and was recruited as a professor by the University of Manchester. It's as though my entire career path has been one glorious, transatlantic conspiracy of positive discrimination designed to overpromote a left-wing black man.

Now, they weren't entirely wrong. Race, after all, had been a factor in our selection to City University (which launched the bursary in response to the racial uprisings of the mid-eighties), my assignment in South Africa (the *Guardian* wanted a black reporter on the ground who could get stories that white counterparts couldn't get) and my column (after the Macpherson report into Stephen Lawrence's death, the *Guardian* thought it was about time). I'd like to think it wasn't the only reason. But it definitely featured.

Just as it was politics that kept black people out of these

spaces in the past, so it follows that it would be politics that made it possible for us to enter. The same was true with the rush to sign up black voices after the Black Lives Matter demonstrations in 2020; the converse is true now as major corporations like McDonald's, Meta and Walmart have announced that they will pare back their diversity initiatives following Donald Trump's election.

A conducive climate for hiring black workers ebbs and flows with the demands of the moment. The year that the Macpherson report came out, both myself and Yasmin Alibhai-Brown were given columns, my first book was published and Steve McQueen won the Turner Prize. A year earlier, Chris Ofili won the Turner Prize; a year later, Zadie Smith's *White Teeth* came out. All of these people are, of course, gifted in their own right. But black people were no less gifted twenty years earlier and yet, between them, race and class blocked their advance.

Nobody died, rioted or campaigned so that I might enjoy my career. They were fighting for justice, equality or against police brutality. But the reality is that had they not fought, rioted or campaigned, I would not have been able to do what I've done. I am as adamant that we should not be proscriptive about what black writers should think and

do as I am that we must acknowledge how we got here and who made the sacrifices to get us here.

Climbing the ladder and then pulling it up, so that others can't follow, is one thing. Setting fire to the ladder and then claiming it never existed, as others are tormented by the flames below, is another.

But the accusation that I wasn't there on merit comes with an implicit assumption that there was a meritocracy at play that I otherwise could not compete in; as though those who went to private school, had relatives and family friends high up in the industry, could afford to do unpaid internships and who were white all made it under their own steam; that while my identity not only shaped but determined whatever success I enjoyed, the identities of those fellow students was incidental if not irrelevant to their advancement.

Such is the lot of those with more powerful identities that they are blessed with not having to understand them as identities at all. Just as no one asks me 'When did you realise you were straight?' (because straight people are never asked that question) or 'How did you balance being a foreign correspondent with having small children?' (because men are not asked that question), nobody enquired if others were there

because they were white, or rich people were there because they were rich, because those questions would seem absurd.

This is why when people talk about the need to trumpet Black Excellence, I counter with an insistence on championing Black Mediocrity: the right for black people to be as average, flawed, compromised and mistaken as any other group of people – the right, ultimately, to be human. Racism is a system of power. You cannot excel your way out of it any more than you can excel your way into the aristocracy. Wealth gives you options, but it does not give you the option not to be black. Class can earn you privileges, but it cannot hermetically seal you from race. There are no short cuts or buy-outs. It's not personal. That's the point. Racial discrimination does what it says on the packet: it discriminates on the grounds of race. It doesn't care about you as an individual. If you want to get rid of it, you have to work with others to dismantle the system.

Holding oneself to an impossible standard in order to prove a point to those who struggle to accept your humanity is a cruel recipe for a mental health crisis. The burden, to which I refer, is not just political or professional. It is psychological.

Now that question 'What qualifies you to be here?', which

I first heard as a student, segued effortlessly into the next question – 'What are you here for?' – when I actually became a journalist. This I will describe as the burden from above and it generally follows two scripts: that you should either only write about race and nothing else or that you should never write about race under almost any circumstances.

The first, that you should only write about race, reduces race to an issue that involves only black people and assigns a black writer's only function as being to chronicle that issue for the benefit of everybody else, while white people can write about anything. My first regular column at the *Guardian*, which I had written about Bosnia, was spiked after the Comment editor at the time thought I should stick to subjects closer to home. 'We have people who can write about Bosnia,' he said. 'Can you add an ethnic sensibility to this?'

The subtext, however, requires further interrogation, for it suggests that white people do not have an ethnic sensibility; that their gaze is both neutral and universal. It also suggests that the piece I wrote did not already reflect an ethnic sensibility and that only the crudest display of my racial authenticity would prove otherwise.

This, in no small part, is about getting a bang for your

buck – or, in this case, money for your melanin. After all, why have a black journalist if you're not going to make a song and dance about it? This is why so often black journalists are strategically placed as front-of-house staff – given prominent positions where people can testify to the diversity of the institution, mistaking photo opportunities for equal opportunities. They are more likely to be columnists or in front of camera – all important jobs to be sure – than in editorial roles which are less obvious but boast more power – like editors or schedulers – because you get to decide the agenda. This discrepancy is most obvious in the BBC, where its flagship television newscasters have a high proportion of black and Asian journalists, while Radio 4's main radio programme, *Today*, has had very few non-white presenters. One can only assume that they think that if you can't see it, it doesn't matter.

The folly of this approach was painfully evident in 2020, when the BBC was forced to apologise for mislabelling the Labour MP Marsha de Cordova, who is black, as another Labour MP, Dawn Butler, who is also black, on its BBC Parliament channel. The *Evening Standard* wrote about the BBC's mistake, but they once again mislabelled de Cordova, publishing instead a picture of another black Labour

MP, Bell Ribeiro-Addy. The *Evening Standard* blamed a wrongly captioned photo provided by Getty Images, the main supplier of editorial images to British news outlets. There were only fourteen women of African descent in Parliament at the time and yet they managed to mix up just under a quarter of them in just a few days. Diversity isn't for display only – or at least when that is the case, it is useless, noxious and ultimately counterproductive.

This is the approach most likely to mine a black writer for their 'first-person experience', as though anyone who commissions or employs you is thereby entitled to your autobiography. The exotic promise of your presence gives currency to your personal story, regardless of how unremarkable it might be.

The first two literary agents I ever met in the mid-nineties, both of whom had approached me, suggested I should write an autobiography.

'But I'm only twenty-eight and I haven't done anything,' I told them.

'But your story is so interesting,' they insisted.

Indeed, they may insist on your story, even when it is humiliating or painful. When the boxer Chris Eubank kicked a taxi after it refused to stop for him, I was asked to

write an article about black people's experience with black cabs. I explained that I had written this very article already, had nothing new to say about it and really, really didn't want to write another one. The section editor told me he wanted it anyway. I stood my ground. So did he. I relented, waiting for a more majestic hill to die on. (I did, however, take the next two days off and refused to call in sick, calling it 'race tax'.)

The second burden from above comes from those who think you should not write about race at all. That might also be known as the 'Be careful or you'll get yourself pigeon-holed' position. To comply, you must leave your identity at the door, rendering yourself simultaneously hyper-visible in the workplace and invisible in your work. It requires you to fold yourself, quietly and unobtrusively, into a normative whiteness, whereby every day is a 'Don't bring yourself to work day'.

This advice was mostly well meaning, usually coming from older, white colleagues who wanted to protect you from those, among their cohort, who wished to reduce you to your racial identity and keep you there.

But the use of the passive voice in their warning tells us almost everything we need to know. Ceding your agency

as a writer and a thinker to unnamed, unknown others because of what they might think of you is not conducive to creativity. As the artist Chris Ofili once told me, when I raised this with him: 'Pigeons can fly.'

But there is a subtext here too, which is that to be a black person writing about racism and centring your experience in your work is limiting. Now that might, in one sense, be true. Black experiences are often not valued on a par with those of white people. It is telling that Black Lives Matter did not gain global attention because more black people were being killed by the police in America, but because more white people decided to take notice. It is also telling that the British media didn't recognise the Windrush scandal as a scandal until around six months after it broke in the mainstream. Black suffering of this nature is not news; it's what the media have come to expect. So focusing on those stories and aligning yourself with those people may well not advance your career.

★

Imploring any journalist not to write about a thing that might interest or impact them seems odd at any time. But given the period when I have been writing, it has struck me

as particularly peculiar. I started my shifts for the *Guardian* a few months after Stephen Lawrence was murdered; I left the paper around twenty-seven years later, just a few months before George Floyd was murdered. In between came Nelson Mandela, Zimbabwe, terror attacks, the Macpherson report, riots in France, Britain, Sweden and the US, Hurricane Katrina, Barack Obama, the Windrush scandal and Trayvon Martin, to name but a few stories in which black people and racism featured prominently.

That is not to say that a black journalist would necessarily be interested in these subjects. But it would be perverse to say that if they did have an interest, they should suppress it. Racism is not a marginal story.

Fascism is now a mainstream ideology on both sides of the Atlantic; last summer saw lynch mobs attack mosques and asylum seekers, while our political culture prioritised demonising poor people, often from countries we have bombed, who risk their lives to escape poverty and war. When people ask why I go on about racism all the time, I say it's because there's a lot of it about; when they say it's predictable to have a black writer write about race, I say it's much less predictable than being asked 'Where are you *really* from?' or than a black celebrity in a nice car being

pulled over by the police. When people used to ask why I didn't write about issues other than race or racism, I'd point out that only between a third and a half of the stories I have written throughout my career were strictly about race, racism or black people. It didn't matter. I have no control over how I'm understood. To them, I would always be, as one *Times* columnist put it, 'the *Guardian*'s black journalist' who writes 'black stories'.

There have been moments when I might have written about something else but felt that I should write a column about the Windrush scandal, Ali G, the French riots, Mike Tyson or Diane Abbott because either the handful of people I would trust to treat the issue responsibly weren't going to cover it or a person I didn't trust to treat it responsibly would.

In the words of the Palestinian poet Marwan Makhoul:

> In order for me to write poetry that isn't political
> I must listen to the birds
> and in order to hear the birds
> the warplanes must be silent.

★

The 'ethnic sensibility' I developed growing up in Britain when I did was not limited to race. Far from it. It shaped my views about how the world was run, who mattered and why, and what I might do about it. Thanks to it, I entered journalism with a healthy, thorough contempt, embedded in my childhood, for the dominant narrative, assuming that the official account of everything was at best suspect, but most likely a downright lie. I 'knew' this in part because I was being lied about constantly.

That's why I encourage younger black journalists, in the moments when they have some control over their output, to cover the things they are passionate about, whether that's fashion, sport, finance or interior design – because that is what they will do best. It needn't be about racism and it needn't be about politics. But they will still be black and employing their perspective in whatever way works for them.

As Toni Morrison said when asked if she found it limiting to be described as a black woman writer: 'I'm already discredited. I'm already politicised, before I get out of the gate. I can accept the labels because being a Black woman writer is not a shallow place but a rich place to write from. It doesn't limit my imagination; it expands it.'[8]

Finally comes the burden from below, which is altogether more complicated. Basically, these are the demands to correct the imbalance, change the narrative and generally represent the interests, values and experiences of 'your' community.

Honourable as this sounds, many narratives, whoever they are about, are complicated. Black people are disproportionately affected by knife crime, but most people killed by knives in Britain are white. American racism may be more lethal than European racism, but black people still have more opportunities to succeed there than in Europe. Many countries in Europe were not colonial powers or slave traders, but colonialism and slavery still heavily impacted the continent as a whole.

Journalism does not always provide the space to explore these nuances (which is one of the reasons why I started writing books and then made the move to academia) or sufficiently flesh out the context. But in the limited space available, it becomes the often isolated, minority reporter's task to unravel these complexities with one eye on editors and a general readership who may not know and may not care about the subtleties, and another audience, within 'their community', who do not see it as nuance at all but

vital background without which you cannot understand the story.

The gaps in knowledge can be vast and echo the power differential. People who were massacred, enslaved, subjugated, tortured or otherwise oppressed don't have the luxury of forgetting what they or their ancestors have been through. The people who did it have demonstrated the capacity to forget, in real time, even as they are doing it.

For example, in 1948, the year HMT *Empire Windrush* docked with its symbolic human cargo of colonial migrants, mostly from Jamaica, a government survey revealed that half the country could not name a single colony – this at a time when the Union Jack flew over much of Africa, Asia and the Caribbean. Sri Lankan-born writer and activist Ambalavaner Sivanandan would later inform anti-immigrant protesters in Britain with shallow colonial memories that 'we are here because you were there'. But, of course, if you never knew where you were or what you did there, then how could you make sense of who was now here and what they thought of you?

A YouGov poll from 2014 revealed that British people estimated that there were four times as many Muslims and twice as many immigrants in Britain as there actually are.[9]

It is the challenge, or at least should be, of all journalists to bridge that gap and furnish their readers with stories that make sense. But the black experience is not just the footnote in a narrative tailored for the comfort of white people who insist on their own ignorance. Indeed, often it is not even the footnote. And while it may be the challenge for all of us to educate the British public about its own history, it is only really a burden for those who will be called on, by the communities of which they are part, to answer for the omission.

So, when under-represented and poorly represented groups appear in stories, activists among them are often not looking for balance, but for advocacy and affirmation. For example, in 2006 I wrote an article about gay life in Jamaica.[10] I went to parties in convoys to protect us from assault, talked to campaigners, academics and partygoers, wrote about homophobia in some dancehall songs, anti-gay murders and the fact that at the time there wasn't a single out gay person on the island who felt able to be a spokesperson for a national report about homophobia. It also dealt with the hypocrisy from much of the West, where homophobia was still common electoral currency at the time, and centred gay Jamaicans' voices throughout, including the fact that virtually all the gay people I spoke

to loved dancehall – it was the homophobia they couldn't stand. Nonetheless, there were quite a few people who told me I shouldn't have done it. They said it added to the UK media obsession with Jamaica's deficiencies, contributed to the sense of black people being brutal and held it to a different standard to many other countries.

I sympathised with the frustration. It is not good enough to simply say: 'All I am doing is presenting the facts.' There are lots of facts in the world; it is up to the journalist to filter them and decide to which facts they wish to give the floor. There are not that many stories, beyond the travel pages, about Jamaica, and most of them are negative. What is the value of having black reporters, one might ask, if they are going to replicate all the prejudices and imbalances that exist already?

A prominent black Labour MP denounced the article in a column in the *Jamaica Gleaner*: 'The problem that I have with [this] article is that I cannot recall the *Guardian* giving similar space and bold headlines to other issues regarding Jamaica and the Caribbean,' they wrote. I then wrote a column denouncing her piece as a 'nationalist race to the bottom'. We got into it below the line. This is why we can't have nice things.

Under-represented communities are, almost by definition, embattled. The more they feel besieged, the more the space for self-criticism shrinks. On the one hand, there is the fear that any self-criticism will be seized upon and weaponised by more powerful people outside the community; on the other, there are those who wish to suppress any dissent or discussion within the community. Such is the dialectic inherent in all identitarian political projects.

Which brings us back to James Baldwin's encounter with those students at Howard. He was right to tell them that they didn't elect him but that whatever he wrote would reflect on them anyway. As writers, we don't represent anyone beyond ourselves. I am accountable to no one. Not so long ago, the handful of black people who did make it through the system often felt they had to be 'ambassadors' for their race. As the first person to integrate an institution or room, they could not just be themselves. On their shoulders ostensibly lay the fate of all who might come after them. Every time they stood up, they checked their fly.

I have never felt this pressure particularly keenly and what little I have felt I have fiercely resisted. Diplomats are accountable to states. I am not. Diplomats enjoy expense

accounts, grace-and-favour accommodation and other perks. I do not. Diplomats get immunity. I do not.

My feeling about the article on gay life in Jamaica was that, since I do not work for the Jamaican government, it wasn't my job to show the country in any kind of light and, while I make no great claims for the piece, it had set the issue in a context that helped clarify how and why this was happening. I am a journalist, not a propagandist. It would be a dereliction of duty, both moral and professional, to abandon my critical faculties at the very moment when they are most needed. That is why I believe Baldwin could not honour his promise not to betray the students. It negates the possibility that, at some time, he might disagree with them and that his critique might actually be helpful, even if not favourable. And there was the even greater possibility that, at some point, they would disagree with each other and he might need to intervene. I would argue here that the real betrayal would have been not to cover gay Jamaicans and the real challenge was to do it in a way that ensured a fair reading would not further entrench the prejudice. Either way, whether it qualifies as a betrayal or not is not in my gift.

★

It is at this point that the burden of representation collides head on with its troubled and increasingly unreliable cousin, the politics of representation. More than a decade and a half after Barack Obama's first election, we, in Britain, have had a prime minister of Asian descent, who took over from a white woman in Downing Street and was succeeded as leader of the Conservative Party by a black woman with Nigerian parents. For all but six days over more than six years, from 30 April 2018 until 5 July 2024, the home secretary was of either Asian or African descent. There is symbolic value to these appointments and elections which should not be denied. As a student, I was part of the Black Sections movement that fought for greater black representation in parliament and the Labour Party. You can't just support more diverse representation when that representation supports you. There is either intrinsic value in it or not. I believe there is. But it is symbolic and has to be weighed alongside the substantial effect these black and Asian politicians had in one of our most reactionary governments, presiding over racist policies (particularly regarding immigration and asylum). Their performance has forced a more nuanced approach to the notion that all we need is more people of colour in the room

and increasingly asks more questions of what they will be doing and saying when they are in that room. In so doing, it has helped clarify what we mean by this 'burden'.

The leader of the Conservative Party, Kemi Badenoch, doesn't represent me. Nor does she claim to. But I don't represent black people either. I don't think she is violating some code for what black people should do, say or think. I just think she's wrong about just about everything. But I don't think she's wrong because she's black and, as I mentioned earlier, black people have the right to be as wrong as anyone else. So, while I hope I speak *to* the black community in a voice that is relevant, informative and engaged, I hope I am never deluded enough to think I can speak *for* it. What would give me the right, when they have voices of their own? Having a platform gives me an audience; it does not give me accountability. As such, the burden I feel increasingly is less of representation than responsibility.

I may not represent black people, but it's nonetheless important that I don't misrepresent them. For it would also be reckless to contribute to an atmosphere in which relatively vulnerable people were made more vulnerable by my work. Responsible but not beholden; substantial as well as symbolic; sympathetic but not pandering; political but not

proscriptive: there's not an awful lot of wiggle room there, but it's the space in which I feel I need to both operate and expand. 'Our worst side has been so shamelessly emphasised that we are denying that we ever had a worst side,' said African American intellectual W. E. B. Du Bois. 'In all sorts of ways, we are being hemmed in and our new young artists have got to fight their way to freedom.'[11]

Such is the nature and providence of the burden. It's coming at you from all sides – at times like a troop of monkeys on your back, at others like a crowd with a bullhorn urging you on – forcing a constant assessment of how you might use the platform that you have most effectively, and with integrity, while keeping your job and your sanity.

Some would claim that this burden is completely fictitious. That it's just a range of voices in my head making demands and applying pressure that does not really exist. That I am free, like any other journalist, to write what I like and face the consequences. That, up until this point, what you have been hearing is a mix of delusions of both grandeur and oppression.

But there is one script that emerges from non-white people more commonly than others, a form of words from people I often respect that seeks to parse the challenge and

chart a way through it, but which, I think, ultimately leaves them in much the same place as they started. 'I don't think of myself as a black writer,' they say, 'but as a writer who happens to be black.'

Now, I understand what they mean. They do not wish to be limited by the racist imaginations of others. Alexis Wright, an indigenous Australian novelist, summed it up earlier this year when she told the *Guardian*: 'A long time ago, I realised I didn't want to fit in anyone's box, particularly what was expected around what an Aboriginal person should write . . . I don't want to just write about myself or what's happening in my house. Literature needs to be more than that.'[12]

Who would want to end up in somebody else's box – and particularly that box? The logic is irresistible. Their race is an element of who they are, which they cannot help and THEY may well have no interest in. Non-fiction writing or journalism is what they do and they would rather be judged by that. It makes sense as far as it goes. Broadly speaking, I respect the sentiment that underpins it. But there are three main problems with it.

The first is a matter of fact. I am a black writer. So are they. That's not all I am. My race doesn't define me. But

it does accurately describe me, if only in part. One has to wonder what is so problematic about the category that one would want to be in flight from it.

Which brings me to the second point. What does it really mean to say that you're a writer who 'happens to be black'? It's sophistry wrapped in a truism. We all happen to be any number of things that we are born with: short, blue-eyed, ginger-haired, long-limbed and so on. But being black is consequential in ways that those other traits are not. Clearly, the fact of it is an issue of chance, but what happens to people who are black is not an issue of chance at all. More likely to be stopped, searched, arrested, incarcerated, unemployed, underpaid and homeless, these things don't just happen to happen to people who look like me. In the West, people 'happen to be black' the same way people 'happen to be' female in Saudi Arabia, Roma in Eastern Europe or Tutsi in Rwanda – identities in places where the thing you 'happen' to be has a huge impact on your life chances. Put more succinctly, in this time and this place, being black is not an insignificant fact of life. And that makes the 'black' in 'black writer' a significant adjective. This is why we never hear a white writer say that they don't think of themselves as a white writer, but as a writer

who happens to be white. It wouldn't make sense. Because whatever limitations exist when it comes to writing – and there are many – being white isn't one of them.

Which brings me to the third point. It matters what you think of yourself as. Of course it does. Self-definition is absolutely fundamental to our agency and self-worth. Nobody else has the right to tell you who you are. But that definition does not exist in a vacuum. It is shaped by circumstance and may be sharpened by crisis. We have a choice about the identities which we recognise, elevate and honour – but at specific moments, those identities may choose us. At any given time, someone is trying to fit us into some box, whether we want them to or not. The question is whether we let them and, if not, how we effectively resist them. We needn't succumb to others' definitions; indeed, it's important that we don't. But we do have to contend with them.

As a student of French and Russian, I spent five months studying in Paris and five months in what was then Leningrad. It was the academic year 1990–1991. My five months in Paris provided some of the most intensely racist experiences I have ever endured. People asked me what colour I was when I called about flats; there were colour

bars in clubs and high-end restaurants; the police stopped and searched me several times a week and beat me up in the Métro after it transpired we had a difference of opinion. I thought I was a student enrolled at the Sorbonne; they thought I was a drug dealer.

My five months in Leningrad were quite different. The Soviet Union was collapsing, leaving the US as the sole global superpower. It was venerated. But Africa, a continent the Soviet Union has been keen to court with student scholarships, military training and infrastructure projects, was considered a drain on scarce resources and emblematic of the folly of Communist solidarity. Most likely as a product of my sneakers, jeans, big loopy earring and hair in plaits, Russians decided I was American. It was the only time in my life that anyone looked at me and thought: 'Here comes money.' It was the only time in my life when I had to vouch for white people when going into hotels and bars. In Paris, I often couldn't stop a cab for love nor money; in Leningrad, cars would stop and turn into cabs at the sight of me, in the hope and expectation that I would pay in dollars.

I was the same person in both places. I saw myself as a British student; they saw me as a drug dealer or an

American. I didn't have to accept that, but I did have to contend with it. Since there is no singular black experience, there is no one way to contend with it. Each must find a way to make it work for them.

Over the years, I have seen that those who tend to cope with it best are those who have some understanding of the politics that got us to this point. Only then can one separate the personal (the microaggressions, the pieces we are writing, the edits we receive, the criticisms we get) from the structural (the racial and racist dynamics that infect the space we are in, the demands from movements, hostility from politicians, occasional ambivalence from our colleagues). Making that distinction does not make the obstacles go away; it simply understands them differently and helps us distinguish those challenges we can do something about ourselves and through our work from those that are part of the broader landscape. It doesn't stop us feeling the things personally – after all, we are people and they are happening to us – but it helps remind us, in good times and bad, that these burdens are part of a larger story of which we are not the sole authors.

Understanding the challenges as political also enables us to deal with them strategically: to give some thought

as to the most effective intervention, as opposed to the most satisfying retort. Is this the right moment? Is that the right person? Where are my allies? How might I frame this? Acting out, calling out, dropping mics and raising Cain are all satisfying. Sometimes they are necessary. But when the rush wears off, they may well leave you more vulnerable than when you started. I had to keep telling myself, 'These are your colleagues, not necessarily your friends, and this is a job, not your whole life. Do your job as well as you can and build your life somewhere else.' The best revenge, I have always thought, would be my happiness, sanity and a body of work of which I could be proud. These are calculations. In the words of the late, great sociologist Stuart Hall, 'there are no guarantees'.[13] As I used to tell younger colleagues who were angry and upset by how they were treated: 'You can resign from this organisation. And maybe you should. But you can't resign from white supremacy.'

As time went on in my career, that strategy changed. Starting out, desperate to make it work, I would triangulate the problems and dismiss the slights because I did not have the leverage, confidence or experience to confront them head on. That was not just about race but age and

hierarchy. When you are junior, you suck it up. I just had more to suck up than most. But, over time, I felt I gained the confidence to choose my hills and not die on them. An older novelist once told me about how he started to stand his ground: 'At a certain point, you realise that while you might take a hit, you will work again, and if you keep it all in, you'll go mad.'

It also requires you not to project your burden onto others. Don't assume other black writers share your worldview or value your strategy. Why should they? Similarly, don't get so comfortable as the only black person in the village that the presence of another feels like a threat. Why should it be? If there's only space for one of you, then it's not much of a space anyway.

Knowing that these racial obstacles were not, by any means, unique to journalism or me made finding how to thrive despite them central to my freedom both as a human being and as a writer. I think of self-definition as an active process of imagining the world you want to live in and then simultaneously working to create it – and, whenever possible, imagining that you are actually living in it.

Toni Morrison described this as a wilful act of defiance in which she dared others to reorient themselves so they

might join her. 'I stood at the border, claimed it as central, and let the rest of the world move over to where I was.'[14]

The late Palestinian intellectual Edward Said evoked a journey in pursuit of what is engaging, forgoing what may be more powerful but also more dull: 'moving away from the centralizing authorities and toward the margins, where you see things that are usually lost on minds that have never travelled beyond the conventional and the comfortable'.[15]

Both dare to conjure the prospect of a world which is wired differently and in which voices, now marginalised, validate themselves. Both carry the very risk that nobody may join you at the border or the margin and you may end up talking to yourself. It is for each to decide whether they think the certainty of a life of racial denial, creative amputation and possible career advancement is worth the real risk of marginality and isolation. As the Mexican revolutionary Emiliano Zapata once said, in an aphorism made famous by Spanish Republican activist Dolores Ibárruri (aka La Pasionaria): 'It is better to die on your feet than live forever on your knees.' But better still would be to find a way to live on your feet.[16]

In the words of the late Black Consciousness champion Steve Biko, 'I write what I like.'[17]

What I like is to be responsible, relevant and engaging. What I like is to think that I might use the space I have to make space for others and to broaden the space for what we all might write. What I like is to think that I am contributing in some small way to a more inclusive understanding of who and what matters and why. What I like is amplifying stories that are rarely heard from people we rarely hear from. What I like is to feel trusted in the communities that are important to me to tell the truth, as I see it, even if it's not what they want to hear.

To that degree, I am grateful for the burden because it has also given purpose, focus and meaning to my work. I write to be liberated from the burdens from above – and for that to be possible, I must write in response to the burdens from below. When that feels hard, I imagine a world without borders, where birdsong drowns out the sound of warplanes, and build my temple for tomorrow there.

# ENDNOTES

1. Gary Younge, 'In Our Own Backyard', *Guardian*, 1 March 1999
2. Neil Thurman, Alessio Cornia and Jessica Kunert, *Journalists in the UK*, Reuters Institute for the Study of Journalism, 2016
3. Office For National Statistics, UK Labour Market, June 2019, published 11 June 2019, https://www.ons.gov.uk/releases/uklabourmarketstatisticsjune2019
4. *Elitist Britain 2019*, The Sutton Trust, 24 June 2019
5. Eddie S. Glaude Jr., *Begin Again: James Baldwin's America and Its Urgent Lessons for Today*, Chatto & Windus, 2021, p. 5
6. Langston Hughes, 'The Negro Artist and the Racial Mountain', *Nation*, 23 June 1996
7. Zora Neale Hurston, 'How It Feels to Be Colored Me', *The World Tomorrow*, May 1928
8. Hilton Als, 'Toni Morrison and the Ghosts in the House', *New Yorker*, 19 October 2003
9. George Arnett and Alberto Nardelli, 'Today's Key Fact: You Are Probably Wrong About Almost Everything', *Guardian*, 29 October 2014
10. Gary Younge, 'Troubled Island', *Guardian*, 27 April 2006
11. W. E. B. Du Bois, 'Criteria of Negro Art', *The Crisis*, Vol. 32, October 1926
12. Sian Cain, 'I Didn't Want to Fit in a Box of What an Aboriginal Person Should Write: How Alexis Wright Found Her Voice', *Guardian*, 11 January 2025
13. Stuart Hall, 'For a Marxism Without Guarantees', *Australian Left Review*, 84, 1983
14. Toni Morrison, 'Toni Morrison Uncensored, Interview with Jena Wendt', Australian Broadcasting Company, 1998
15. Edward Said, 'Intellectual Exile: Expatriates and Marginals', *Grand Street*, No. 47 (Autumn, 1993), p. 124
16. Emiliano Zapata, 'Mexican Revolutionary', in Jennifer Speake (ed.), *Oxford Dictionary of Proverbs*, Oxford University Press, 2015, p. 22
17. Steve Biko, *I Write What I Like: Selected Writings*, Heinemann, 1987

# Author Events
*Exclusive Editions*
# Literary News
*Book Discounts*

Get closer to the books you love.
*Join Faber Members for free.*

Join today at
**faber.co.uk/faber-members**

faber
*members*